CHESTER

HISTORY TOUR

ACKNOWLEDGEMENTS

This book could not have been compiled without the help of my good friend and respected Chester historian Len Morgan. And of course, as usual my wife Rose for her patience during the writing of the book.

First published 2016

Amberley Publishing
The Hill, Stroud,
Gloucestershire, GL5 4EP
www.amberley-books.com

Copyright © Paul Hurley, 2016
Map contains Ordnance Survey data
© Crown copyright and database right
[2016]

The right of Paul Hurley to be identified as the Author of this work has been asserted in accordance with the Copyrights, Designs and Patents Act 1988.

ISBN 978 1 4456 5703 5 (print)
ISBN 978 1 4456 5704 2 (ebook)

British Library Cataloguing in Publication Data.
A catalogue record for this book is available from the British Library.

Typesetting by Amberley Publishing.
Printed in Great Britain.

AUTHOR INFORMATION

Paul Hurley is a freelance writer, author and is a member of the Society of Authors. He has a novel, newspaper and magazine credits and lives in Winsford Cheshire with his wife Rose. He has two sons and two daughters.

Contact www.paul-hurley.co.uk

Books by the same author:

Fiction
Waffen SS Britain

Non-Fiction
Middlewich (with Brian Curzon)
Northwich Through Time
Winsford Through Time
Villages of Mid-Cheshire Through Time
Frodsham and Helsby Through Time
Nantwich Through Time
Chester Through Time (with Len Morgan)
Middlewich & Holmes Chapel Through Time
Sandbach, Wheelock & District Through Time
Knutsford Through Time
Macclesfield Through Time
Cheshire Through Time
Northwich Winsford & Middlewich Through Time
Chester in the 1950s
Chester in the 1960s
Chester Pubs (with Len Morgan)
Northwich Through the Ages
A History Tour of Macclesfield

INTRODUCTION

A history tour of Chester would have to include the Roman period in the days when Chester was called Deva Victrix. At that time Chester was a fortress town in the, then, Roman province of Britannia. The walled fortress of the city was built during the AD '70s period and was completed over the coming years by the Legio XX Valeria Victrix. Chester is quite unique in that those walls that enclosed the fortress city are still there; damaged and rebuilt over the years, but still available to walk around. The Chester fortress is the biggest in the country and the probable reason for this is it was meant to be both the capital city of a Roman ruled British Isles, and also a base from which to invade Ireland. A thriving port at the time, Chester was ideally situated for the purpose being the highest navigable port on the Dee.

A quick mention here of one of Chester's most famous historical features, The Rows. They are continuous half-timbered galleries which form a second row of shops above those at street level. They can be found along Eastgate Street, Northgate Street, Watergate Street and Upper Bridge Street. Nothing the same exists anywhere else in the world. They date from the medieval period and could originally have been designed to protect the pedestrian from the ordure and filth that would have been in the street at the time. It was also a convenient way of fitting more shops into a smaller footprint, whatever the reason, they are certainly a feature to be enjoyed today.

Damage to Chester's infrastructure began with the building of the inner and outer ring roads. Started before the Second World War, these roads, the inner one in particular, cut a swath through some ancient and attractive buildings. But it is time to go and take a look at what historic Chester has to offer and what better way than taking a walk around the 2 miles of walls, a most pleasant activity and one that locals and tourists alike enjoy. It is possible to join the walls at any point and continue along until that point is reached again. For our walk we will start at the Little Roodee, now a large car park that sits in the shadow of the famous Grosvenor Bridge.

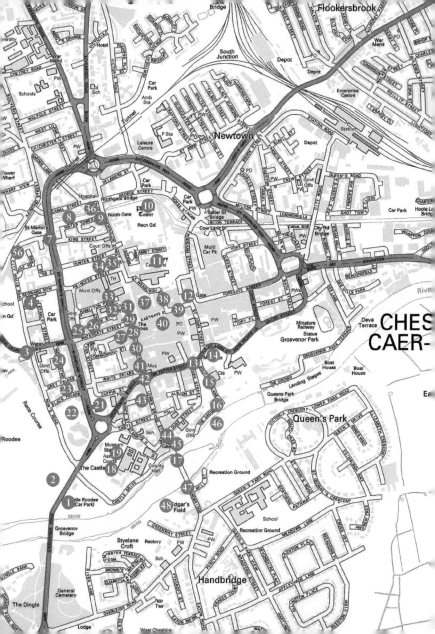

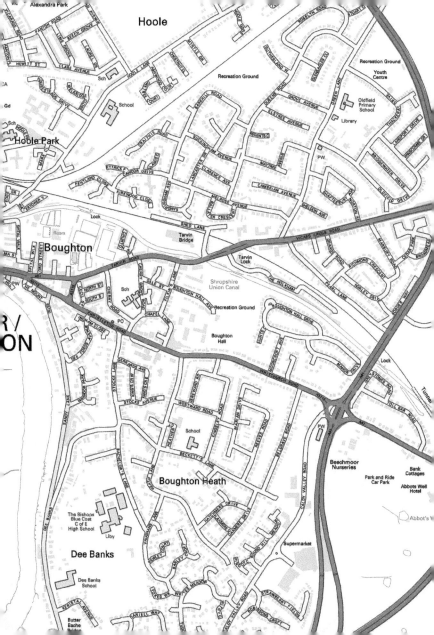

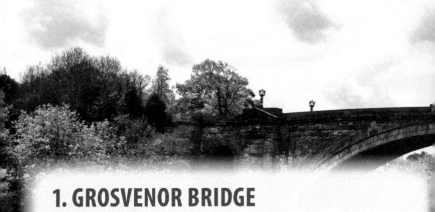

1. GROSVENOR BRIDGE

Grosvenor Bridge is a single-span stone-arch road bridge crossing the River Dee and carries Grosvenor Road over the river. In the nineteenth century Chester was a major shipbuilding city, and a very tall bridge was required to allow ships to pass underneath. It was designed by the famous architect Thomas Harrison and opened by Princess Victoria of Saxe Coburg-Saalfeld, soon to become Queen Victoria. It had an arch 60 feet (18 m) high and 200 feet (61 m) wide. A scale model of the bridge can be found alongside the path next to the car park (see inset). At the time of its construction, the bridge was the longest single-span arch bridge n the world, a title that it retained for thirty years and it is a Grade I listed building. Construction began with the first stone laid by the Marquess of Westminster on 1 October 1827 and was finally completed in November 1833, a toll was also imposed to pay the hefty £50,000 construction costs. The toll proved harmful to trade and was abolished in 1885 when maintenance was transferred to Chester Corporation.

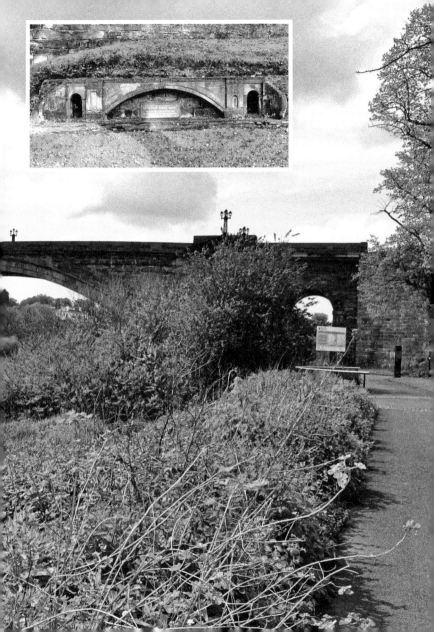

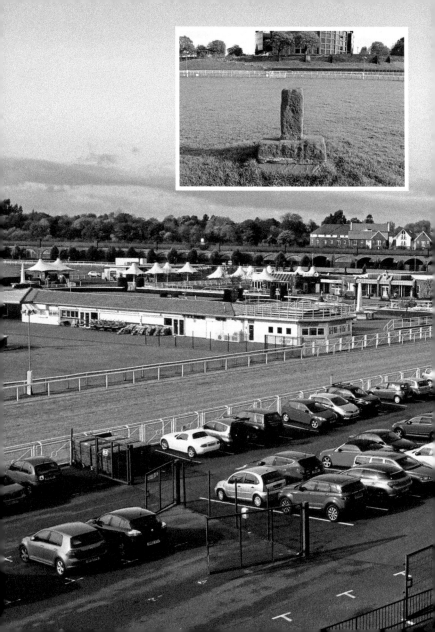

2. CHESTER'S RACECOURSE

Walking now up the hill to Grosvenor Road, past the abovementioned bridge model and putting Chester Castle to our right, we cross the main road and having done so are now on the walls proper. On the left, spread out below is the Chester racecourse known as The Roodee. It is listed as the oldest racecourse in England, and one of the shortest. Roodee is a corruption of the words *rood eye* meaning 'the island of the cross'.

This comes from a story regarding a statue of the Virgin Mary holding a large cross being buried in the centre of what was then a small island surrounded by water in around 946. Below the walls the river used to run here during Roman times and trading ships would tie up to unload their cargo directly on to the walls; the course of the river was later changed.

The north of the Roodee course is bordered by a long railway bridge carrying the North Wales Coast railway line over the River Dee. The course is overlooked from the opposite bank of the river by the expensive dwelling houses of Curzon Park, which can be seen dominating the skyline.

In the 1500s horse racing was brought here. The first recorded race was held on 9 February 1539 but this is disputed by some. The mayor of Chester at the time was Mr Henry Gee, whose name led to the use of the term 'gee-gee' for horses. If we look to the right as we walk along we see roads with the names of the monks and nuns who once lived there, Grey Friars and Black Friars, further in can be found White Friars and the road that runs parallel to the walls here is called Nun's Road.

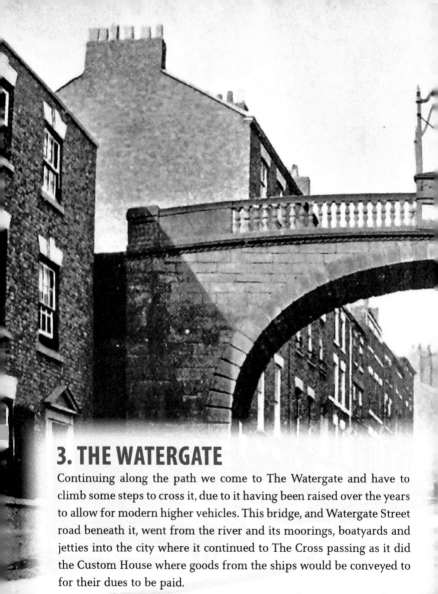

3. THE WATERGATE

Continuing along the path we come to The Watergate and have to climb some steps to cross it, due to it having been raised over the years to allow for modern higher vehicles. This bridge, and Watergate Street road beneath it, went from the river and its moorings, boatyards and jetties into the city where it continued to The Cross passing as it did the Custom House where goods from the ships would be conveyed to for their dues to be paid.

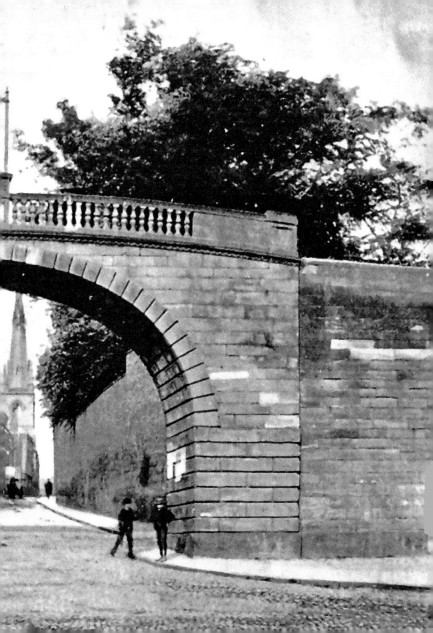

4. CHESTER ROYAL INFIRMARY

Soon the road name changes from Nun's Road to City Walls Road and the large building on the right is the old Chester Royal Infirmary, now converted to apartments. The Chester General Infirmary building was built between 1758 and 1761 and was opened on 17 March 1761. The infirmary was one of the most progressive hospitals of its time. Four storeys high, facing west, it overlooked the River Dee and Welsh hills and accommodated 100 beds. In 1914 George V opened a new ward called The Albert Ward and at the same time declared that the hospital should, in future, be known as the Chester Royal Infirmary. The original building of the Chester Royal Infirmary was the main acute hospital in Chester for 232 years until its inpatient work was transferred to the Countess of Chester hospital in 1993. The infirmary was closed for good in 1996, the oldest part of the original hospital building has been retained and converted into apartments, calling it the '1761' development, the original opening date of the hospital. Almost all of the remaining hospital buildings have been demolished and replaced with houses and flats.

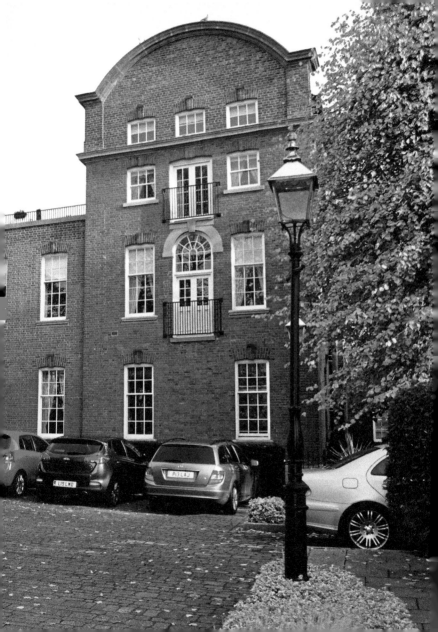

5. BONEWALDESTHORNE'S TOWER AND THE WATER TOWER

Part of Chester's old port (inset), where ships would discharge their cargo. Carrying on we come to a junction in the walls. Here the spur on the left ends with the water tower that was built 1322–25 and at the time of building actually stood in the River Dee. Also here is Bonewaldesthorne's Tower which can be dated to 1249 and was rebuilt and altered 1322–1326 to become the gatehouse to the water tower. In 1838 the newly formed Chester Mechanics' Institute leased the two towers from the city council to use as a museum. Its name is rumoured to be the name of an officer in the army of Aethelflaeda, Lady of Mercia. The towers were closed to the public in 1916 and are only open to the public on certain days of the year.

6. GOBLIN TOWER ON THE CITY WALLS

Passing along the path we reach another tower, this unusual half tower was originally called Goblin Tower, a name that can still be seen at the top of it together with its rebuild date of 1894. It also bears the name Pemberton's Parlour after John Pemberton, a rope maker and mayor of Chester in 1730. It has a well-worn sandstone tablet naming the mayors and the men responsible for repairing the wall in days long gone. The main damage had been caused in the Civil War, before that the tower was completely round and what we see now is half of the original tower. The old photograph shown in the inset dates from 1908 with the railings from the aforementioned Chester Royal Infirmary.

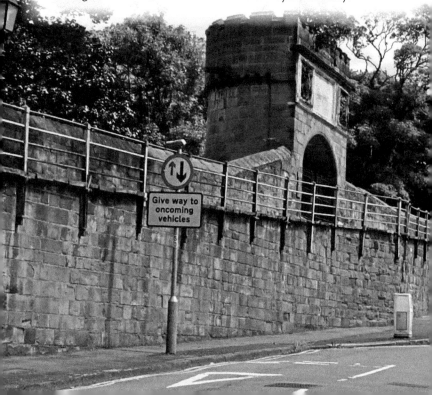

Give way to oncoming vehicles

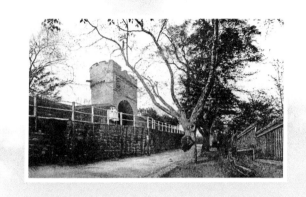

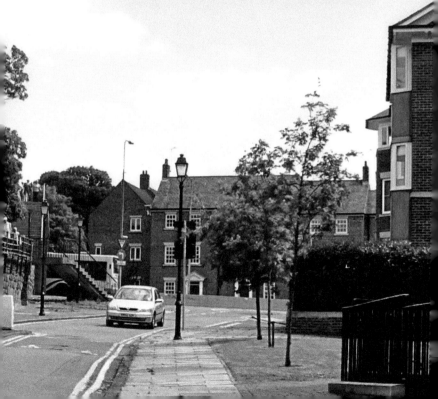

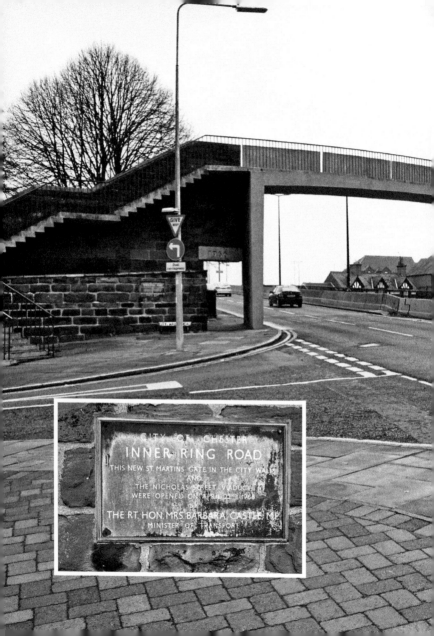

CITY OF CHESTER
INNER RING ROAD
THIS NEW ST MARTINS GATE IN THE CITY WALLS
AND
THE NICHOLAS STREET VIADUCT
WERE OPENED ON APRIL 22ND 1966
by
THE RT HON MRS BARBARA CASTLE MP
MINISTER OF TRANSPORT

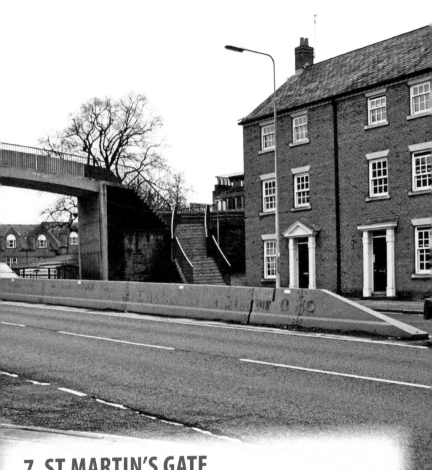

7. ST MARTIN'S GATE

Continuing now we come to a bit of a climb as we reach St Martin's Gate, a new gate over the inner ring road built in 1966 and with more headroom for traffic, it is also the only gateway or tower on the walls that is not a listed monument. The inset shows the plaque indicating its opening by Barbara Castle MP, the then Minister of Transport.

8. MORGAN'S MOUNT

Carrying on now from the St Martin's Gate we see the road to our right is Water Tower Street and to our left as we start to climb again is Morgan's Mount. This is a Grade I-listed building that was constructed in 1645 during the siege of Chester in the English Civil War as a gun emplacement and observation platform. At this time the Royalists in the city were being besieged by the stronger Parliamentary army. The siege lasted from February 1645 when the gun emplacement was built until January 1646 and during it the gun sited on the mount was destroyed by the Parliamentarians. Originally it was called the Raised Square Platform but later the name was changed to the officer responsible for it, Capt. William Morgan, a Royalist defender. The top is now fenced in and gives a good view to those walking to the top.

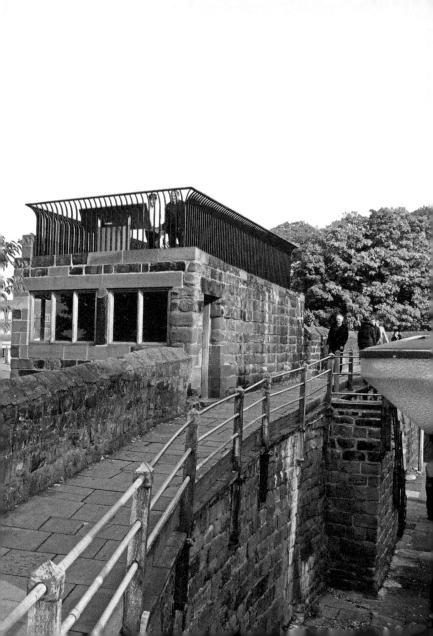

9. THE NORTHGATE

As we leave the Mount and look to our left we see the Chester canal across the gardens of the houses sitting against the wall. To the right are modern houses on the site of the Northgate brewery which ceased brewing in 1969 and was demolished in 1971. The path gets steeper as we approach the Northgate. This gate stands on the site of the original northern Roman gateway to Chester and was once a narrow and unimportant gateway for local access. During the medieval period it was rebuilt and consisted of a simple rectangular tower but this was later greatly expanded and also became the site of the local gaol where prisoners were kept in the most basic of accommodation to await their fate. Then in 1810 Thomas Harrison added the rebuilding of the gate to his many projects in the city.

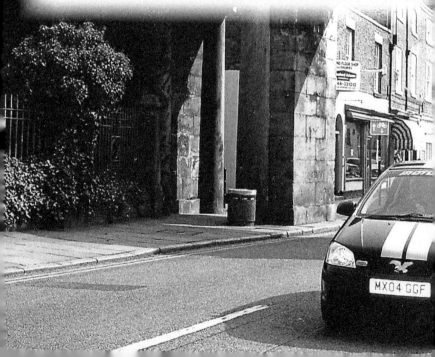

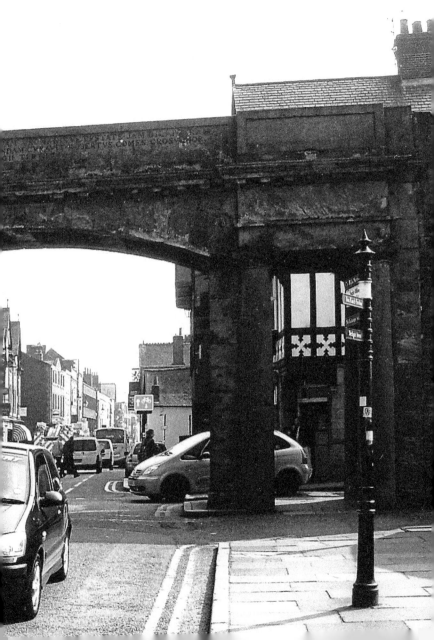

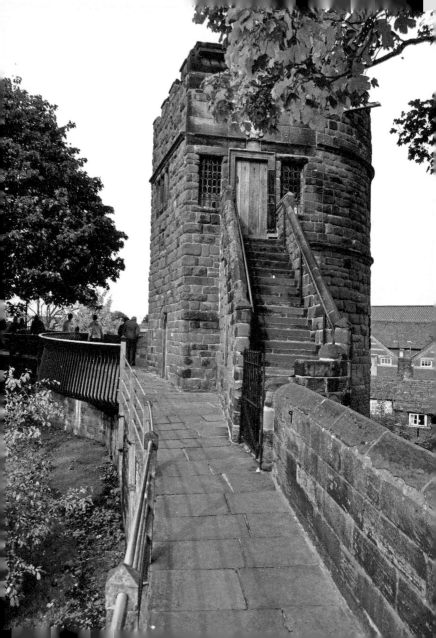

10. KING CHARLES TOWER

Continuing now along the walls and to the left is a steep incline to the canal far below as we approach Chester Cathedral. Soon on our left we reach another tower, this one titled King Charles Tower, Phoenix Tower or the Newton Tower and is another Grade I listed building. Dating from the medieval period, by 1612 after much use, the tower's fabric was in poor condition. It was restored and above the door a plaque was fixed giving the date of 1613 and a carving of a phoenix, the emblem of the guild responsible for the restoration. During the Civil War, the tower had a gun on each storey and it was damaged in the conflict. A plaque on the tower states that Charles I stood on the tower on 24 September 1645 and watched as his soldiers were defeated at the battle of Rowton Heath in the distance. The king made a temporary escape into Wales via the old Dee Bridge.

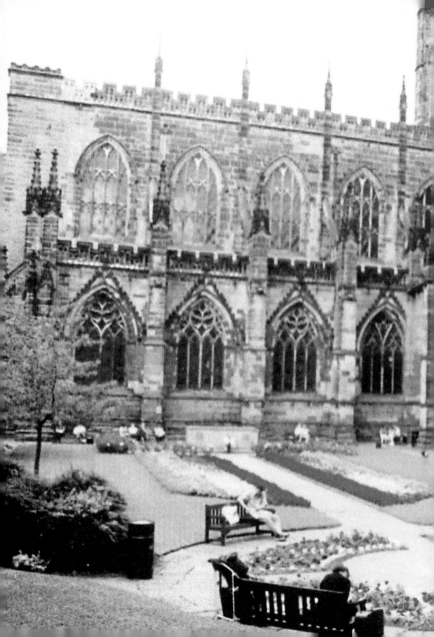

11. CHESTER CATHEDRAL

Further along the footpath, to our left we have the Frodsham Street area leading from the canal into the city centre and soon on our right we come to the cathedral. The photograph shows the view of the cathedral from the walls and a flower garden set out in the form of a military medal as a garden of remembrance for the Cheshire Regiment, now the Mercian Regiment. The cathedral was originally a Benedictine abbey dedicated to St Werburgh established on the site by Hugh Lupus, Earl of Chester with the assistance of St Anselm and other monks in the late twelfth century. At this time Chester Cathedral was not located at this site but was at the nearby church of St John the Baptist. In 1538, during the Dissolution of the Monasteries the Benedictine monastery was disbanded and the shrine to St Werburgh was desecrated. In 1541 the building became a cathedral of the Church of England by the order of Henry VIII and the name was changed to Christ and the Blessed Virgin.

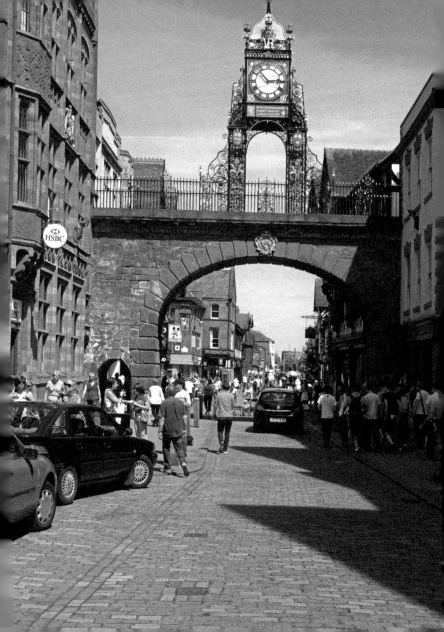

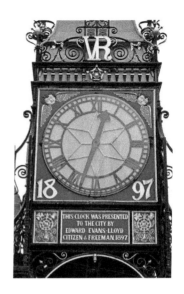

12. THE EASTGATE AND ITS CLOCK

Leaving the cathedral we now reach the Eastgate with its famous clock, said to be the second most photographed in England after Big Ben. It was designed by the architect John Douglas to celebrate Queen Victoria's Diamond Jubilee and was built by the cousin of John Douglas, James Swindley of Handbridge. The clock itself was provided by J. B. Joyce and Co. Ltd of Whitchurch. It had to be wound by hand every week and by the early 1950s the clock was in need of repair. J. B. Joyce agreed to dismantle and overhaul the clock in September 1953 for the sum of £50. The original gate was guarded by a timber tower and was replaced by a stone one in the second century. This gate was demolished and replaced in around the fourteenth century. The present gate dates from 1768. The views from the top in both directions are of two of Chester's main streets, Northgate Street to the left and Eastgate Street to the right.

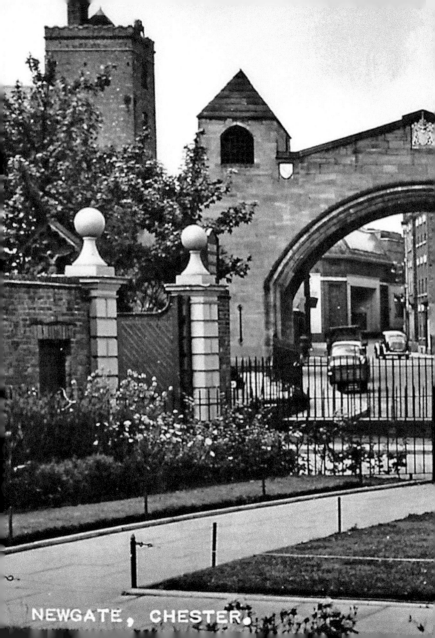

NEWGATE, CHESTER.

13. NEWGATE

Shortly we come to a large and impressive gate called Newgate. It was built in 1938 when the walls were breached here to allow traffic to flow more freely. Again the walkway is raised to pass over the bridge but this leaves us with an excellent vantage point at the top to view the amphitheatre. There is also a view in the distance of the church of St John the Baptist, for a while Chester's cathedral. During the eleventh century, Earl Leofric was a benefactor of the church and in 1075 Peter the Bishop of Lichfield moved his See to Chester, making St John's his cathedral until he died in 1085; his successor moved his seat to Coventry and St John's became a co-cathedral. The bridge was built in red sandstone and designed by Sir Walter Tapper and his son Michael. Unlike quite a few modern buildings in Chester it was generally well received by historians and the general public alike.

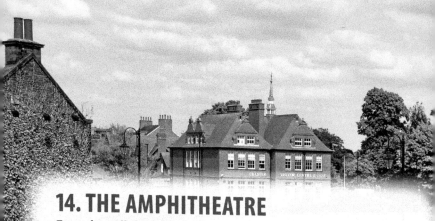

14. THE AMPHITHEATRE

From the walls by Newgate there is a good example of what was once there during Roman times. The site seems to have long remained an open area where the citizens came to congregate, play and worship, a bear pit here also provided a source of local 'amusement'. The arena was still visible as a shallow depression in the ground as late as 1710. Dee House was built in around 1730 as a town house for John Comberbach, a former mayor of Chester and used as a private residence until around 1850. In 1925 Dee House was taken over by the Ursulines, a religious order of nuns. Dee House still exists and is sitting on part of the amphitheatre, within half a century the northern half of this ancient gem had disappeared under houses and the remains of the monument quickly became lost to memory.

Local historians pondered its location, knowing that it was in Chester but having no idea where it was until a gardener from the Ursuline convent came across some stones during his gardening chores. The inset shows the amphitheatre from above.

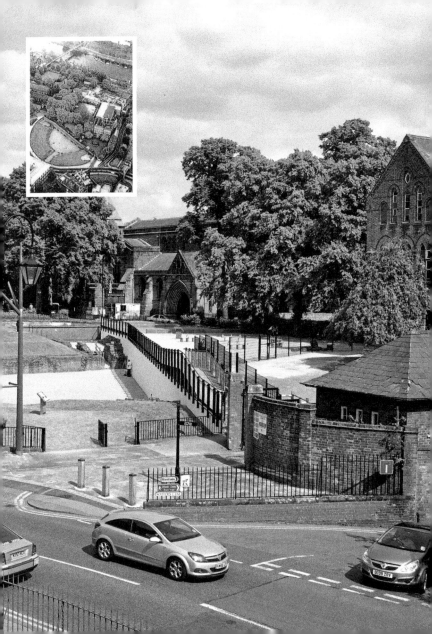

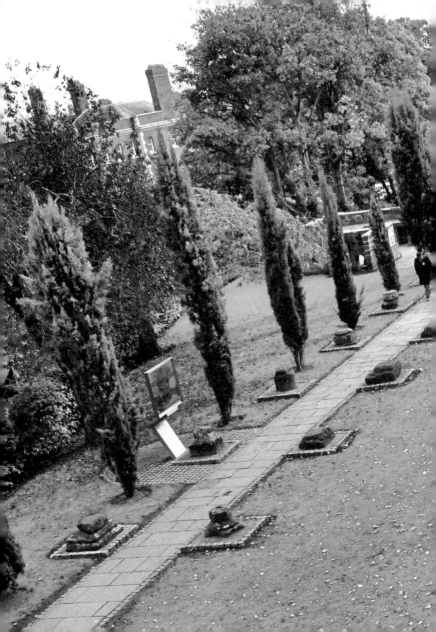

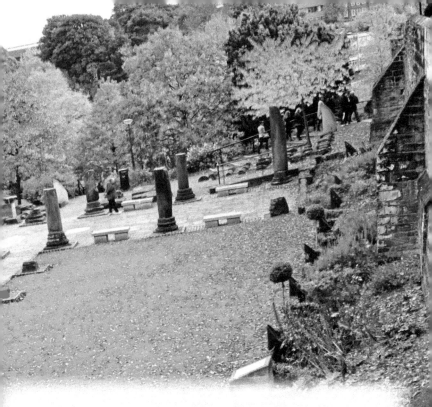

15. ROMAN GARDENS

Passing over Newgate you can see the steps that lead down to the Roman Gardens on the left. These gardens date from the 1950s when they were created as a public park, specifically to display a collection of carved building fragments from the Roman legionary fortress of Deva. Included in the collection are pieces from the most important military buildings including the main baths and the headquarters building. Most were found towards the end of the nineteenth century when excavation work in Chester was under way. All in all a very pleasant outdoor museum.

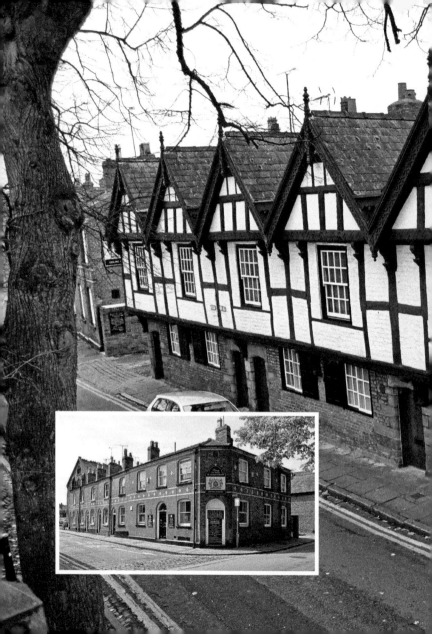

16. NINE HOUSES

Still walking the walls, we look to the right and see a row of almshouses that were built *c.* 1650. By 1960 the houses were in a poor state and campaigns locally were set up to preserve them. By this time all of the tenants had been rehoused and a report was prepared for the Society for the Protection of Ancient Buildings. After being awarded a £5,500 grant from the Historic Buildings Council in 1968 Chester City Council agreed to renovate and rebuild them. Although known as The Nine Houses, only six remained and, as can be seen in the modern photo, the row is now a very attractive sight that greets walkers on these walls. The Albion pub in Park Street adjoins the remaining houses and was recorded as a pub and brewery in 1860. It has remained as a pub since then, and now has quite a unique ambience. The inside is a veritable museum with war memorabilia and old advertising signs, probably one of the most original English pubs. Families with children are not permitted and like in the 1960s, the pub closes every afternoon.

17. BRIDGEGATE

Continuing along the walls we come to our last gate, namely Bridgegate. This gate allows access from the Old Dee Bridge into lower Bridge Street. During the twelfth century the Roman walls were extended and this section of the wall incorporated the original Bridgegate, which must have been there since before the 1120s as old records show that the sergeant of the gate had an office within the gateway at this time. This gate guarded the southern entrance into the town and the road from Wales that crossed the Old Dee Bridge. This bridge was rebuilt towards the end of the fourteenth century at which time the gate would have been rebuilt. In 1600 a square tower was added and this contained machinery for drawing water from the river for use in the city. The gate was destroyed during the siege of Chester in the English Civil War, 1644–45 and the present gateway and bridge was built in 1781, the architect being Joseph Turner.

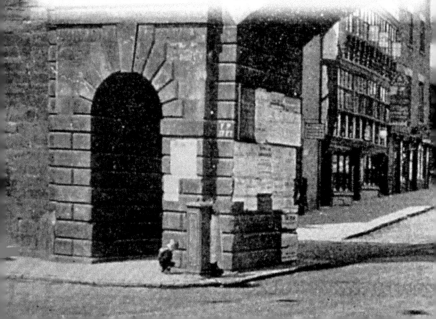

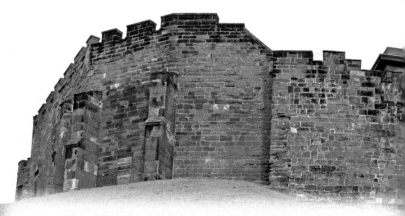

18. CHESTER CASTLE AND THE FORMER TOWN HALL

Leaving the walls behind we pass what used to be the town hall on the right. This was the site of the original Chester Gaol and the main buildings of the jail had been demolished in 1900 leaving some of the cells and the courts, which were used by the County Hall to store documents. The County Hall shown in the photograph was later built on the site and opened by the queen in 1957. It was sold to Chester University in 2010 and the council moved to the HQ building. The castle is to our right as we rejoin the walls and continue towards Grosvenor Road. In 1070 Hugh Lupus was the first Earl of Chester and he undertook the building of Chester Castle. It was built in the form of a motte-and-bailey castle. Over the years the castle suffered during the trials and tribulations of Chester with wars, both civil and with the Welsh, the prison became unserviceable and towards the end of the eighteenth century Thomas Harrison was commissioned to rebuild the prison and the castle.

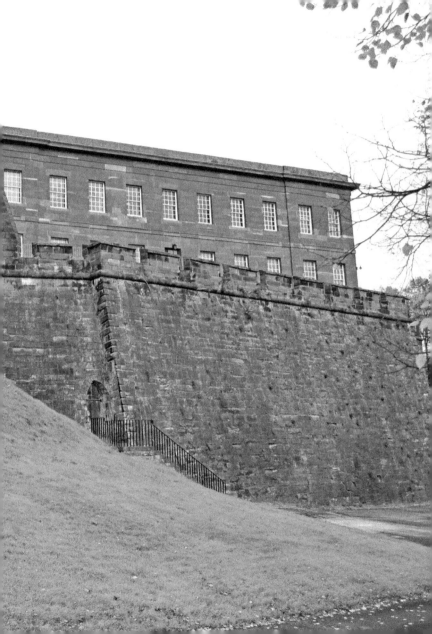

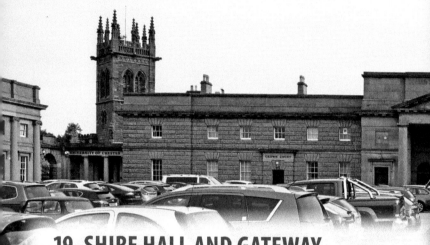

19. SHIRE HALL AND GATEWAY

We say goodbye to the Chester walls now and observe the spectacular gateway to what is now the Crown Courts and Military Museum. The prison was completed in 1792 and Harrison then started work on the medieval Shire Hall in neo-classical style. He built two wings to the main building, one to act as barracks, now the Military Museum and one to act as an armoury, later the officer's mess. The main Shire Hall became Chester Crown Court with Harrison's pièce de résistance, the gateway. He built a massive portico styled in the form of a Propylaeum in Greek neo-classical style with four Doric columns. Historian Nicolas Pevsner described it as 'one of the most powerful monuments of Greek Revival in the whole of England'. The church tower in the background was once St Mary's on the Hill, during the 1970s it closed as a church and became an educational centre that is available for concerts and exhibitions. The statue in the road is of Field Marshal Stapleton-Cotton, 1st Viscount Combermere of Bhurtpore and Combermere in Cheshire.

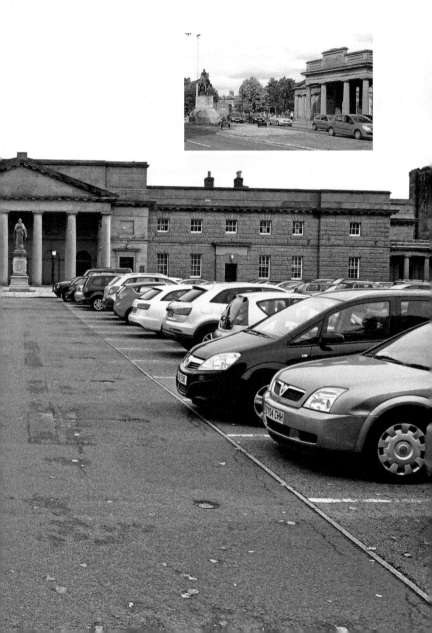

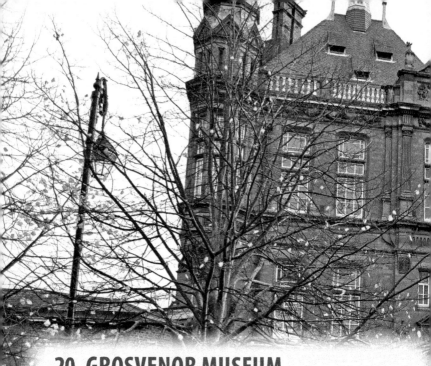

20. GROSVENOR MUSEUM

Passing the gateway now and crossing the road with the large roundabout to our right we come to the Chester Grosvenor museum. Housed in a beautiful red brick building, the museum was founded in 1885, the plot of land on Grosvenor Street was given to the founders by the 1st Duke of Westminster, family name Grosvenor, who also donated £4,000, (£320,000 in today's money). Thomas Lockwood was appointed as the architect and the foundation stone was laid in 1885 by the Duke and then opened by him a year later. A major extension was built in 1894 and in 1915 the City of Chester took over the administration of the museum. In 1938 the authority took full control of the collections and displays. What Chester now has is a first-class museum and a few hundred yards away an excellent military museum in the grounds of the Crown Court.

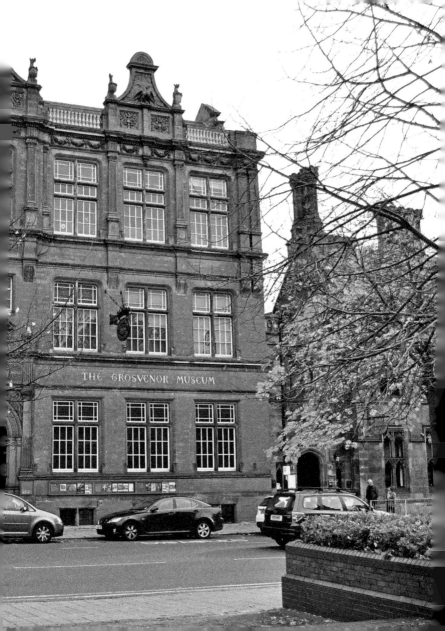

THE GROSVENOR MUSEUM

21. ST FRANCIS CATHOLIC CHURCH, GROSVENOR STREET

Crossing over the road here we see a very attractive church with an equally pleasing building alongside it. The smaller building was once the friary for the Capuchin monks from the church. The mission of Capuchin friars was begun in 1858 and the first mass was said in Bishop Lloyd's house, Watergate Row. An attempt from 1862 to build a permanent church off Cuppin Street and Grosvenor Street was initially thwarted by an earthquake, and later, in 1863, by a hurricane. By 1875 the new church was built on the site designed by James O'Byrne. The friary next to the church – also designed by O'Byrne – opened in 1876. In the 1980s this friary building was disposed of, becoming a hostel for homeless men and the friars moved into a smaller modern building. The church, however, is still going strong.

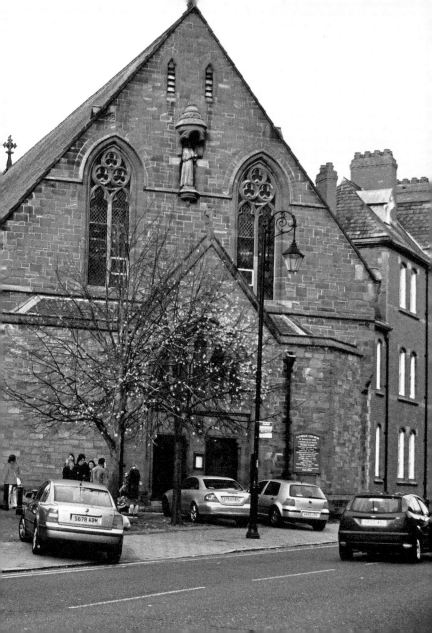

22. THE ARCHITECT PUB

Crossing the road now passing the Chester Magistrates' Courts with the large HQ hotel and council offices opposite and we see, set back off the road, a very attractive large white house. The impressive house was built for, and designed by, the renowned architect Thomas Harrison (1782–1828). It was in thanks for the work he had carried out in the city that paid for it. It was built as The Rectory and later St Martin's Villa on the site of what were convent gardens. The house later became an annexe of the police headquarters that once stood next door and is now a very comfortable pub with the name The Architect as a tribute to Harrison.

23. PILLBOX PROMENADE

Continuing now along Nicholas Road, which is in fact part of the ring road and on our left we come to an impressive row of Georgian terraced houses. They were built in 1780 having been designed by Joseph Turner originally consisting of ten town houses. Because many of the houses were used as doctors surgeries the row became known as Pillbox Promenade. It is the longest and most uniform of any Georgian properties in Chester. Before the inner ring road was built, Nicholas Road was a narrow road leading out of the city.

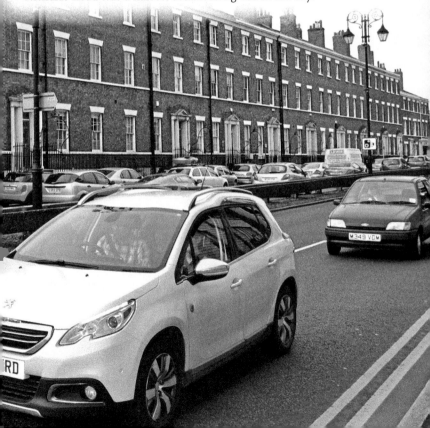

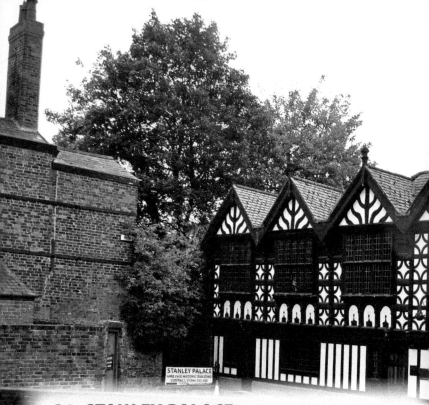

STANLEY PALACE
HIRE THIS HISTORIC BUILDING
CONTACT: 01244 325 585

24. STANLEY PALACE

We now reach the junction with Watergate Street and to our left is the black and white façade of Stanley Palace, said to be the most haunted building in Chester. This house was built in 1591 on the site of a former Black (Dominican) Friary for Sir Peter Warburton. When he died in 1621 his daughter inherited the house and she married Sir Thomas Stanley who gave the house its name. After the English Civil War, the 7th Earl, James Stanley, was held under arrest in the palace to await transport to Bolton for his execution. Plenty of interest for ghost hunters, I would imagine.

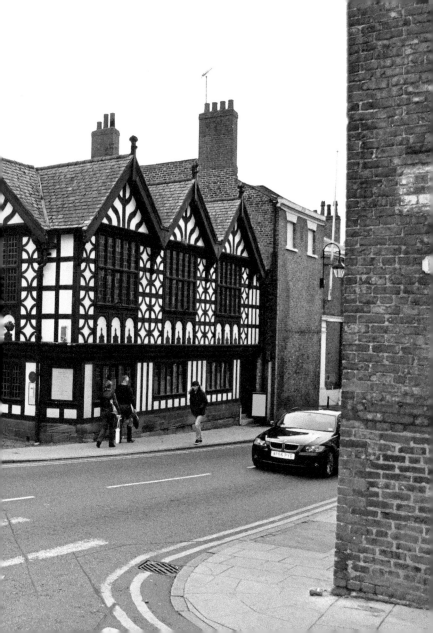

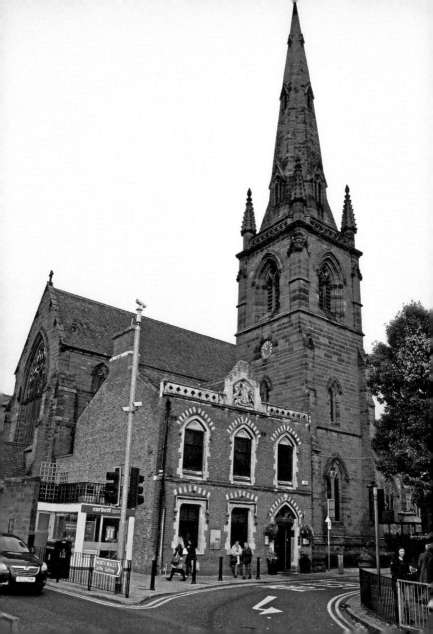

25. UPPER WATERGATE, ST HOLY TRINITY CHURCH

Crossing the road now into Upper Watergate Street and on the corner is the building that used to be Holy Trinity Church. The original church that occupied this site probably dated from the fourteenth century, perhaps serving the seamen from the port below. The present church was built between 1865 and 1866 to a design by James Harrison but he died before the building was completed. The church closed in 1960 and since then has been Chester's Guildhall. It is a good time perhaps to differentiate between the two architects called Harrison. Firstly, Thomas Harrison (1744–1829) born in Yorkshire, buried at Chester, he designed the Grosvenor Bridge and the prison etc. Then James Harrison (1844–1866), born and buried in Chester, who tended to specialise in churches with exceptions and is considered to be the pioneer of Black-and-white Revival architecture.

26. BISHOP LLOYDS PALACE

Now we come to No. 41 Watergate Street and a building known as Bishop Lloyds Palace. This ancient house originated as two town houses which were built on medieval undercrofts and then rebuilt during the seventeenth century when the two buildings were converted into one. The house has been associated with George Lloyd, who was firstly Bishop of Sodor and Man (1599–1605) and Bishop of Chester (1605–1615). This probably accounts for the seventeenth-century carving on the front elevation which includes the Legs of Man and three horse's heads for both the bishopric and the Lloyd family. By the nineteenth century it had become run down, the carvings on its frontage had been covered with plaster and the house was becoming derelict. In the 1890s the house was heavily restored by Thomas Lockwood and a further restoration was carried out between 1973 and 1977. The building now houses the Chester Civic Trust and is available for visits and hire subject to the Trust.

27. GOD'S PROVIDENCE HOUSE

Continuing along Upper Watergate Street we come to an example of the work of James Harrison because another of his projects was the repair to this building. No. 9 Watergate Street which includes Nos 11–11a Watergate Row. This was to save it from being demolished. The building originally on this site dated from the thirteenth century and the present house was built in 1652 incorporating some timbers from the original building. The name of the house originated during a plague outbreak in 1647–48 that killed 2,000 in the city, the people here were spared the disease. As you can plainly see, this house was not built until about four years after the plague so the name probably carried forward from the last house. Next door is the Watergates pub which is situated in one of the old undercrofts so well worth a visit if only to view the ancient architecture.

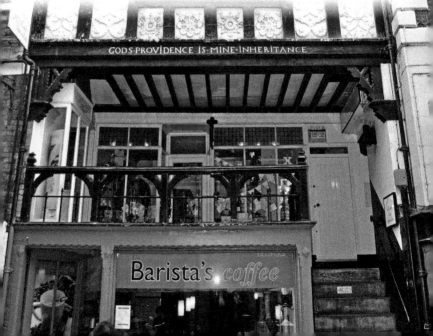

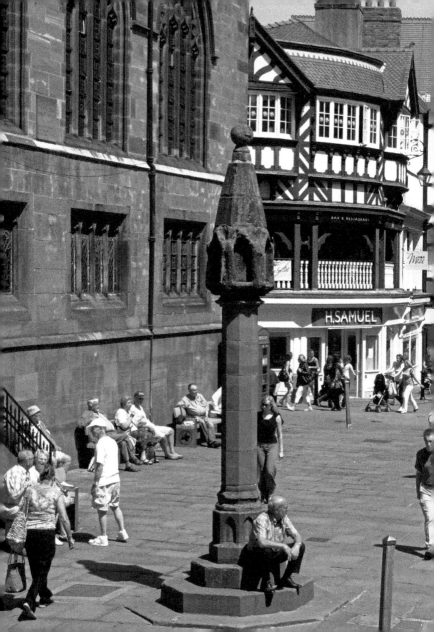

28. THE CROSS

At the end of Upper Watergate Street we find the Chester Cross, sited at the junction of Northgate Street, Eastgate Street, Watergate Street and Bridge Street. This medieval cross was destroyed like others during the Civil War in the name of iconoclasm. In the case of the Chester Cross, for use elsewhere. For instance the base was taken to Plas Newydd, the home of the Ladies of Llangollen in Wales where it still lies. The only truly original piece is the top of the shaft which once contained small statues in the niches. It was not until 1804 that parts of the cross were recovered from beneath the church steps and given to Sir John Cotgreave for use in the garden of his new house 'Netherleigh' at Handbridge but eventually they were returned to the city. The head of the cross went to Grosvenor Museum and the cross with new additions was re-erected elsewhere, eventually returning in the 1970s from whence it came. This area has always been of great importance to Chester and it was here that, in 1649, Charles I was declared a traitor.

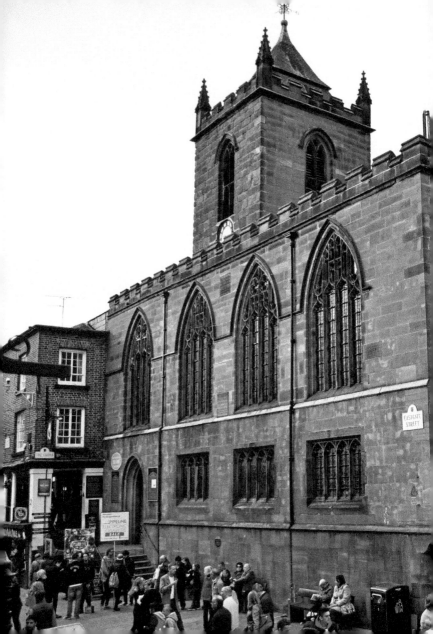

29. THE CHURCH OF ST PETER

The church dedicated to St Peter was founded in AD 907 by the Lady Æthelfleda and some of its fabric dates from that time. The church stands on the site of part of the Roman Praetorium and was in 1086 referred to as 'Templum Sancti Petri' in the Domesday Book. The present church dates from the fourteenth, fifteenth and sixteenth centuries, with further modifications in the following three centuries. Formerly the tower had a spire which was removed and rebuilt in the sixteenth century, taken down in the seventeenth century, then rebuilt and finally removed 'having been much injured by lightning' in around 1780. In 1849–50 the church was repaired by James Harrison and 1886 it was restored by John Douglas, which included the addition of a pyramidal spire. The church of St Peter now looks down serenely into Upper Bridge Street.

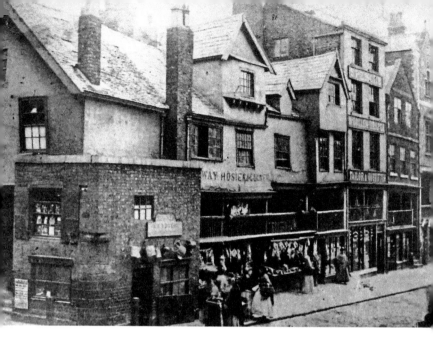

30. BUILDINGS AT THE CROSS

As we look from the ancient cross at the beautiful black and white buildings, purists may be critical of them as they only date from the late 1800s. This, however, is unfair criticism as it is these relatively modern buildings that add so much to Chester's charm. The photographs are a good example of what was there and what has replaced it. The black and white building was designed by Thomas Meakin Lockwood as was a lot of Chester's 'black and white'. This building was erected in 1888 after the older one was so decrepit that it had to be knocked down. Notice the buildings further down Bridge Street are still in situ. So this is an example that Chester is still filled with genuine antiquity but some of the later buildings are equally as attractive.

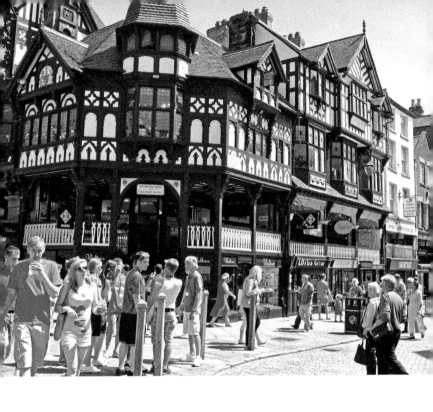

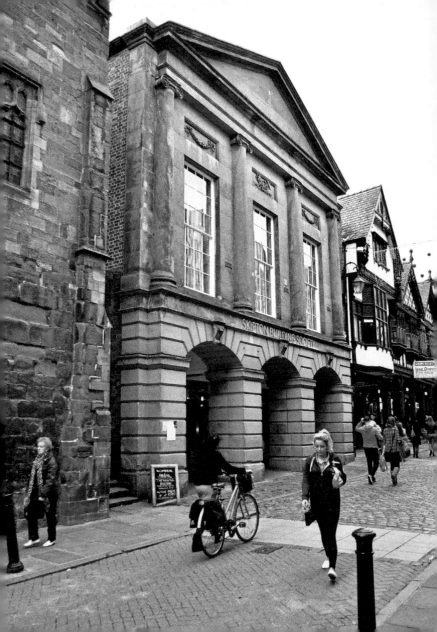

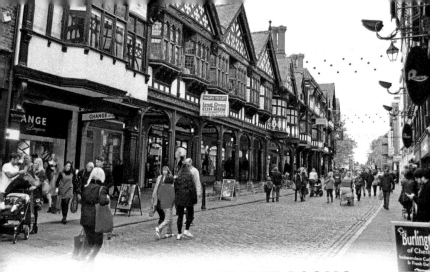

31. THE COMMERCIAL COFFEE ROOMS AND NOS 3–31 NORTHGATE STREET

This building is situated at No. 1 Northgate Street and was designed by Thomas Harrison and built in 1807. It became known as The Commercial Coffee Room and later the Commercial Newsroom. The newsroom had its own committee and at the time its automatic members included the City Mayor, local MPs and senior military officers. Since the mid-nineteenth century it has been known as The Chester City Club, one of the oldest in the country.

Now we pass the Coffee Rooms and look at the rest of the rather attractive buildings in this street. Nos 15 and 17 were designed by James Strong in 1909, the latter as a pub, the Cross Keys Inn. In the cellar of No. 23 can be seen the remains of the columns from the principia of the Roman fort that once occupied the site. No. 25, formally the Woolpack Inn, was rebuilt by John Douglas in 1903 and modernised in 1914 by James Strong. Nos 27–31 on the corner has views into Northgate Street and the Town Square. The whole row was refaced in black and white by John Douglas in 1902.

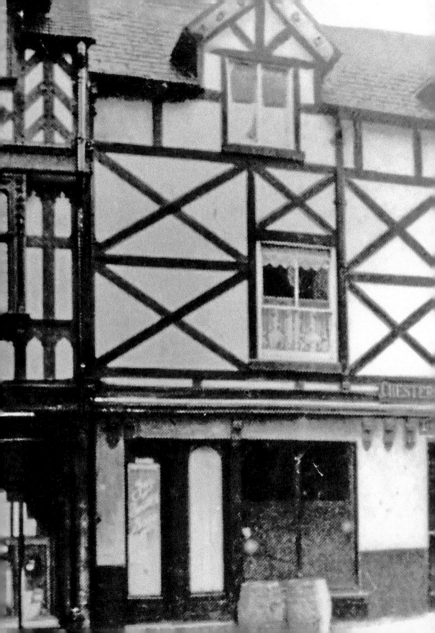

32. THE DUBLIN PACKET

This pub was built originally in the early 1800s and situated at the side of the Market Square, it has now been half hidden by the questionable rebuilding that took place some time ago. It is believed that the name comes from the time when a packet boat would leave Chester docks for Dublin regularly. There was quite a famous licensee later in the pub's life and that gentleman went by the by the name of William Ralph 'Dixie' Dean. During a glowing football career he played for a number of teams, notably Everton when he was known as 'England's greatest goal scorer'. Dixie Dean followed up an exceptionally successful career in football, as a shopkeeper of sports goods in Birkenhead. Then along came the war and Dixie was called up and had a good army career playing and managing service football as well as being a corporal mechanic. Shortly after the war, Dixie took over the Dublin Packet and remained there for around sixteen years. This was the heyday of the Dublin Packet, a very happy pub that was constantly visited by the famous and not so famous paying homage to the great man.

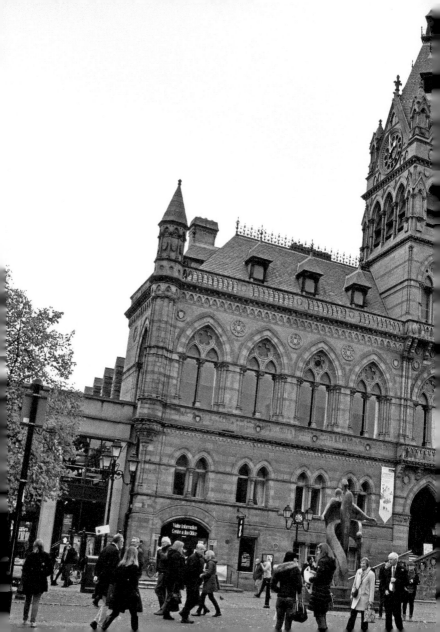

33. THE TOWN HALL

The town hall has had a varied history, in 1698 an exchange was built to accommodate the city's administrators but this building burnt down in 1862. A competition was held to build a new town hall and this was won by William Henry Lynn of Belfast. The building was officially opened on 15 October 1869 by the Prince of Wales (the future Edward VII) who was accompanied by PM William Gladstone. On 27 March 1897 the council chamber on the second floor was gutted by fire and it was restored by T. M. Lockwood the following year. For many years until 1967 Chester's main police station was situated on the town hall's ground floor. Chester originally had its own police force, the Chester City Police under its own Chief Constable. The old police station's cells in the town hall still exist as does the old Magistrate's Court or Quarter Sessions of the City of Chester that were held in this court until the abolition of Quarter Sessions by the Courts Act 1971. From then until 1993 it was used as a Magistrates' Court, with the adjoining room as a retiring room for the magistrates. One of the remaining original Victorian courts in the country, it has been used in film making, such as *Sherlock Holmes* and *Far from the Madding Crowd*.

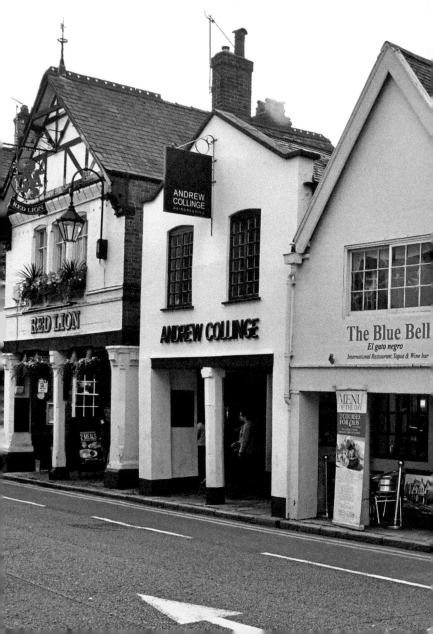

34. THE BLUE BELL INN

The Blue Bell Inn at Nos 63–65 Northgate Street is possibly the oldest domestic structure in Chester, it dates back to the mid- to late fifteenth century. The braced roof points to a construction date of the present building of between 1250 and 1400 although parts of the building may date back to the eleventh century. It formed part of Lorimers Row, a group of buildings with an arcade at ground level. The first licence to serve alcoholic drink was issued in 1494, making it the oldest surviving example of a medieval inn. You will see a small square hole in the upper part, this was level with the top of carriages and was used to sell tickets to those riding there. Successive councils had proved unwilling to spend money on conservation. In 1959 the corporation announced that the building was in such disrepair that it was to be demolished. The ensuing campaign ended when the government refused to permit demolition, and in the early 1960s the corporation had to spend £2,500 on preserving the building. This ancient pub has the pavement running through the ground floor of the building; it originally consisted of two medieval houses which were joined together in the eighteenth century.

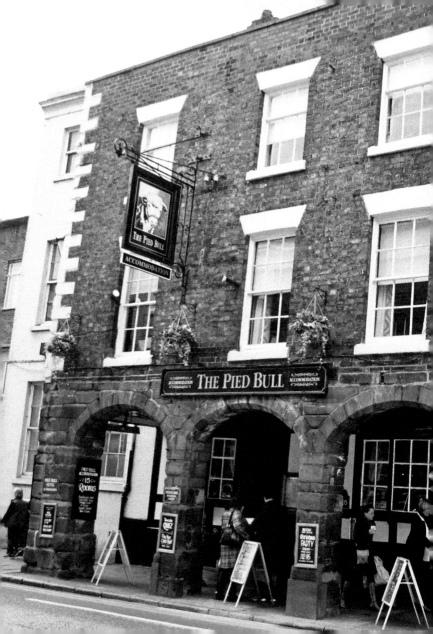

35. THE PIED BULL

Now we have reached probably the oldest continuously licensed pub in Chester which was built somewhere within the thirteenth century as a mansion house going by the name of Bull Mansion. The land to build it was given by the nuns of St Mary and dwelling houses were built here in 1267. It has a hand-made staircase dating back to 1533 when it was rebuilt and became the home of the Recorder of Chester. Around twenty years later it became an inn and was called the Bull Inn reflecting the existence of the cattle or beast market outside the nearby Northgate, this was later changed to The Pied Bull, becoming an important coaching inn. In 1660 it was largely rebuilt and then again in the mid-1700s when it received the brickwork style that we see today, although it is still a timber-framed building dating from the year that it was built. It is filled with period charm and has been tastefully modernised through the years.

36. THE BRIDGE OF SIGHS
AND BLUECOAT HOSPITAL

We just take a quick peep out of the old gateway and look through the railings above the canal. On the left in Upper Northgate Street is the Bridge of Sighs, so-called because it was a footbridge that led across the canal from the Northgate Gaol to the chapel in the Bluecoat School where the prisoner could receive the last rites before they went to meet the executioner. The school is by the city walls, located through the gate and immediate right. The Bluecoat is the prestigious building on the other side of the canal. Before the Bluecoat School was built it was the site of a medieval hospital. In 1717 this school was built for a charity called the Society for Promoting Christian Knowledge. It was originally 'L' shaped but in 1733 a north wing was added. In 1949 the school closed and is now occupied by part of the University of Chester.

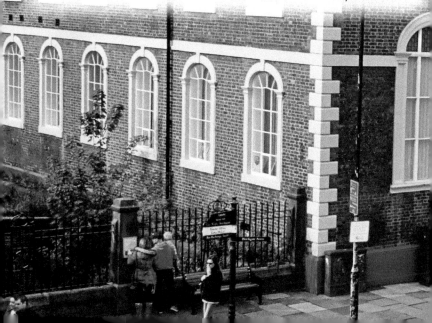

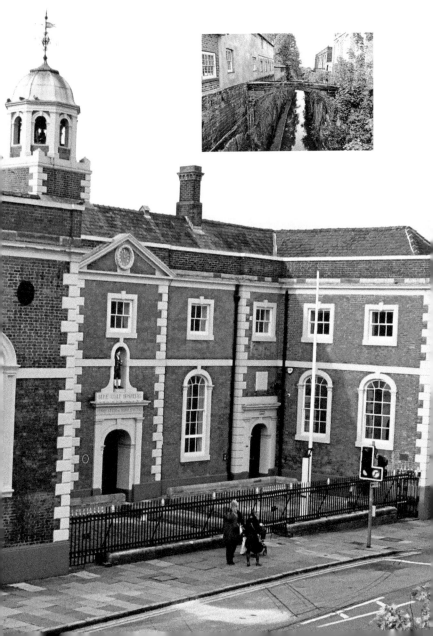

37. MUSIC HALL CINEMA

This building at the junction with Northgate and St Werburgh Streets was once home to the Music Hall Cinema. Abbot Simon of the Abbey of St Werburgh constructed the original building in 1280 as a chapel dedicated to St Nicholas. The old chapel was later used as a wool hall and served as the Common Hall in 1545–1698. From 1773 it was called the New Theatre, renamed the Theatre Royal in 1777, superstars of their day appeared such as Sarah Siddons in 1786 and Edmund Kean in 1815. In 1855 the building became the home of The Chester Music Hall, after being redesigned by architect James Harrison. Many famous faces gave talks here including Charles Dickens in 1867. The London Animated Picture Co. ran films here in 1908. Films were screened on a regular basis from 1915 when it was known as Music Hall Pictures and was an early cinema. In April 1961 the music hall closed, the final offering was *Never on Sunday*. Since closure the building has had many uses, including a branch of Lipton's, Chester's first supermarket within the walls. It is currently home to a branch of Superdrug.

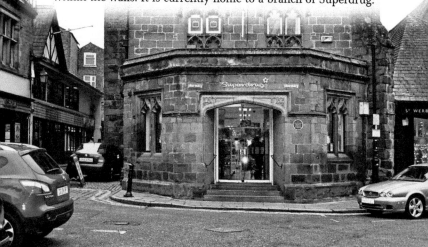

38. ST WERBURGH STREET

Continuing along St Werburgh Street past Chester Cathedral and on the wall here we see a plaque honouring the man responsible for a lot, but not all, of the black and white buildings in Chester, namely John Douglas. The famous Cheshire architect came from Sandiway near Northwich and his superb works can be found across the county and further afield, not to mention the famous clock above the Eastgate. Next to this is Chester's top hotel, The Grosvenor, a name that you will come across in many parts of Chester thanks to the family name of Gerald Grosvenor 6th Duke of Westminster, who lives in Chester at Eaton Hall. St Werburgh Street leads to the Cathedral. This street was once half its width until it was widened and the east side redeveloped by the corporation with the backing of the Duke of Westminster and the designs of architect John Douglas. Douglas wanted to build it in another of his favourites, red brick, but the duke intervened and ordered him to build it in his trademark black and white mock-Tudor, a request that John complied with.

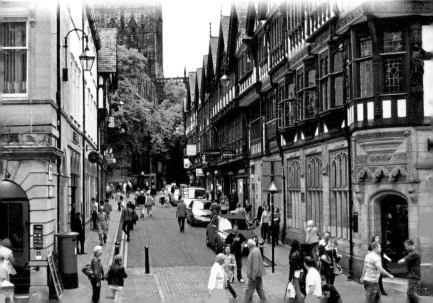

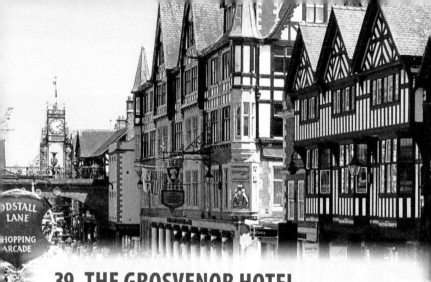

39. THE GROSVENOR HOTEL

Over the road from St Werburgh Street, close to the city walls at the Eastgate can be found the most palatial hotel in Chester. This five-star hotel built in 1863–66 is owned by the Duke of Westminster. Before the present building was constructed the site was occupied first by the pub, The Golden Talbot and later by The Royal Hotel. The Golden Talbot was recorded as being 'ancient' in 1751 when it was mentioned in one of the local weekly newspapers and had been in operation during the reign of Elizabeth I. In 1784, the pub was demolished to make way for The Royal Hotel, built by the politician and landowner John Crewe. In 1815 it was purchased by Robert Grosvenor who was at that time Earl Grosvenor and who later became the 1st Marquess of Westminster. It was then renamed the Grosvenor Hotel, and it became the city's 'premier place to stay'. While it was in possession of the 1st Marquess' son, Richard Grosvenor, 2nd Marquess of Westminster in 1863, the old building, once the Royal Hotel was demolished and the present Grosvenor Hotel, was built. It was designed by Thomas Mainwaring Penson and was Penson's last major work. It was completed after his death by his son's firm R. K. Penson & Ritchie.

40. THE BOOT PUB, EASTGATE STREET

As we walk up Eastgate Street past the Grosvenor Shopping Centre at row level can be seen the Boot Inn which first opened in 1643. Although it has been refurbished over the years, most of the antiquity is still present. The cellar of the pub is below street level with a barrel vault. The walls of the barrel-vaulted stockroom are medieval, the interior is very original. It was built from ships' timbers from the boatyards in the old port. During the English Civil War and the 1645/46 siege of Chester it was used as a meeting place by Royalist troops and when Cromwell's troops invaded the city, they entered The Boot and shot those in there. During Victorian times the pub was used as a brothel. In those days the front of the pub was a barbers shop and a 'madam' organised the 'ladies of the night' at the rear. During the 1920s a gambling club was opened in one of the rooms. The pub was extensively restored in the 1980s when a time capsule from 1882 was found containing a copy of the *Cheshire Observer*.

WESLEY-BARRELL Interiors

Three

1274

48

SHOP UNIT
TO LET

EO Oliver

41. THE THREE OLD ARCHES

This building known as The Three Old Arches is of extreme architectural importance, it is located at No. 48 Upper Bridge Street and together with next door, No. 50 is a Grade I listed building. Part of the Chester Rows are incorporated into the building and the stone frontage of No. 38 is believed to be the earliest shop front still surviving in England. The building was constructed in the thirteenth century and during the fourteenth century it was extended into what is now No. 50. At that time the hall was set parallel to the rows. It was once known as the largest medieval town house on the Chester Rows and still serves as a shop.

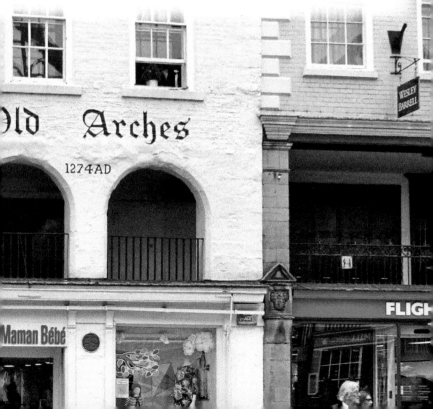

42. ST MICHAEL'S CHURCH

In 1972 this church on the junction of Pepper Street and Upper Bridge Street was closed as a church but in 1975, went on to become Britain's first heritage centre. A lot of the church was rebuilt by James Harrison in 1849 to 1850. A church on this site was burnt down in the great fire of Chester in 1188 and although it is not known when the first stone church was built, the chancel was built in 1496. In 1582 the church was almost completely rebuilt. During the siege of Chester in the 1640s it was used as a prison and in 1710 the steeple was built. Its parish registers go back to 1560.

43. THE FALCON

This building that sits on the corner of Grosvenor Street and Lower Bridge Street started life as a house in around 1200 and was later extended to the south along Lower Bridge Street, with a Great Hall running parallel to the street. During the thirteenth century it was rebuilt to incorporate its portion of the row. It was rebuilt again during the late sixteenth and early seventeenth centuries, and in 1602 it was bought by Sir Richard Grosvenor who extensively altered it some forty years later as his town house. In 1643 Sir Richard petitioned the City Assembly for permission to enlarge his house by enclosing the portion of the Row which passed through his property. This was successful and it set a precedent for other residents of Lower Bridge Street to do the same or similar. In the late eighteenth century the building ceased to be the Grosvenor family town house although it continued to be owned by them, and in 1778–1878 it was licensed as The Falcon Inn. In the 1800s it was restored by John Douglas and The Falcon became the Falcon Cocoa House serving only non-alcoholic drinks. In the 1960s the pub lay empty but it was later restored by The Falcon Trust and reopened as one of Chester's ancient and popular watering holes.

44. ST OLAVE'S CHURCH, LOWER BRIDGE STREET

Another important building in this city of important buildings, situated in Lower Bridge Street, an area that was in the very early days a Scandinavian settlement. The church is one of the oldest buildings and the parish was founded in the eleventh century and is dedicated to Ólaf Haraldsson, St Olave, a Norwegian king martyred in 1030. The area being a Scandinavian/Viking settlement was probably due to its location near to the port of Chester. The present church dates from 1611. In 1841 the parish was united with St Michaels and James Harrison restored the building and converted it for use as a school. In 1972 it was declared redundant again and has since been used as a Pentecostal church and exhibition centre. It is currently supported by scaffolding and wooden planks.

**First Church of Christ,
Scientist, Chester**

**Christian Science
Reading Room and
Book Shop**

Allan Jenkins & Co
Accident Repair Centre
Kelton Court, River Lane,
Saltney, Chester 01244 674649

45. THE BREWERY TAP AND GAMUL HOUSE

Set back from the road, this building played an important part in Chester's history. Known as Gamul House it was once a Jacobean Great Hall that had been built for the Gamul family and is the only stone-built medieval hall to survive in Chester. This family were very wealthy merchants in the city and powerful enough to support their own army. This army was lent to Charles I who stayed here from 23 to 26 September 1645.

Parts of the present building date from around the early sixteenth century with the oldest visible areas being the wall and fireplace behind the bar. The Gamul family lived here during the sixteenth and seventeenth centuries. Thomas Gamul was the city's recorder and his father was mayor on four occasions. His son Sir Francis was a staunch Royalist residing here during the Civil War and was responsible for the city's defences. The last night that Charles I stayed was before the Battle of Rowton Moor, and it was from here that he will have walked to the city walls to watch his army lose. The king made his escape across the old Dee Bridge and into Wales. The painting is likely to date from the seventeenth century.

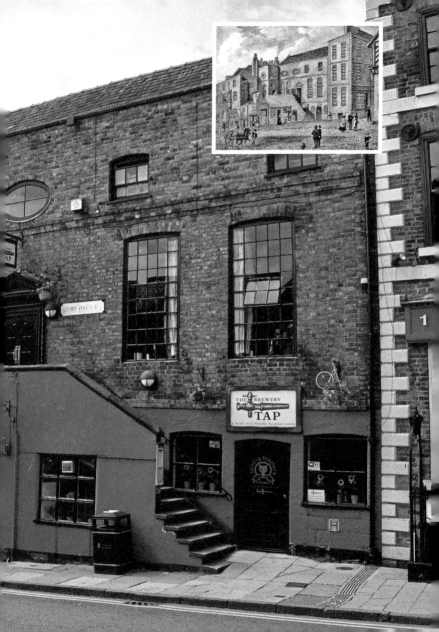

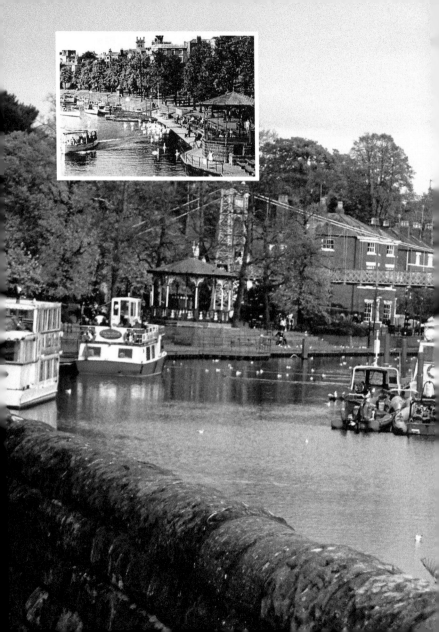

46. THE CHESTER GROVES AND FOOTBRIDGE

Here we see two photographs, one of the Groves at the riverside in 1960 (inset) and a modern shot of the footbridge across the river. The Groves is a riverside walk from Lower Bridge Street to Grosvenor Park with many benches and a bandstand, at certain times of the year boat trips may be enjoyed. The suspension footbridge across the Dee from the Groves to Queens Park was built in 1852, demolished in 1922 and rebuilt in that same year.

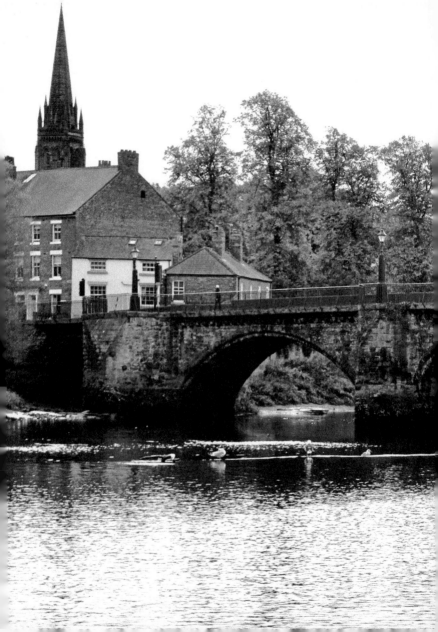

47. OLD DEE BRIDGE

Now for a bit more real antiquity, in the year 911 there is record of a ferry at this location but the famous Old Dee Bridge was recorded in the Domesday Book of 1086. The early bridges were made of wood and were frequently washed away. In 1357 Edward, the Black Prince ordered the mayor of Chester to build it properly and ordered his own mason and surveyor to assist. The bridge built at this time was the one that we see today albeit being rebuilt and repaired over the years. It was the bridge that Charles I used to escape the city after his troops were routed. Hence, the present bridge dates from around 1357 when the old bridge was rebuilt. In 1825–26 the bridge was widened by Thomas Harrison to provide the footway and Harrison then went on to design the Grosvenor Bridge a few years later.

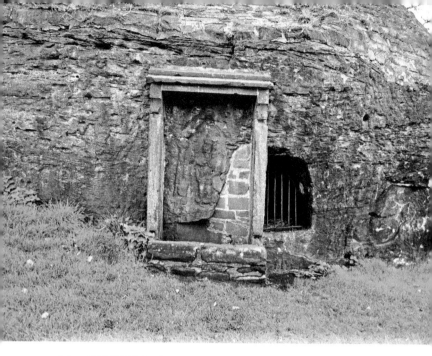

48. STATUE OF MINERVA, EDGAR'S FIELD

Finally we cross the Old Dee Bridge into Edgar's Field on the other side where we find a statue of Minerva who is the Roman goddess of war. Not very impressive at first sight but this is Grade I listed. It is the only monument of its kind in Western Europe that remains in its original position although a cast of it is in the Grosvenor museum. The carving has weathered over the centuries and suffered from some vandalism. Next to the shrine is an opening in the rock face that is known as Edgar's Cave. The shrine stands beside the route of the old Roman road that leads into the fortress of Deva from the south. It was the site of a quarry that provided some of the stone for the Chester walls and other buildings.